# Enchanted Forest To Color

Falena Magnussen

Copyright © 2012 Falena Magnussen
All rights reserved.

ISBN: 1492893633
ISBN-13: 9781492893639

Acknowledgements

My warmest heartfelt gratitude goes to my daughters:
Cherista (nurturing botanical Pixie),
Noella (tropical rainbow Sprite),
Nathania (Wind Fairy),
Claurissa (Storm elemental),
And Pamela with Angelique Sorena Crystal Aurora (Solar Princesses),
Who pose for twice for your coloring pleasure.

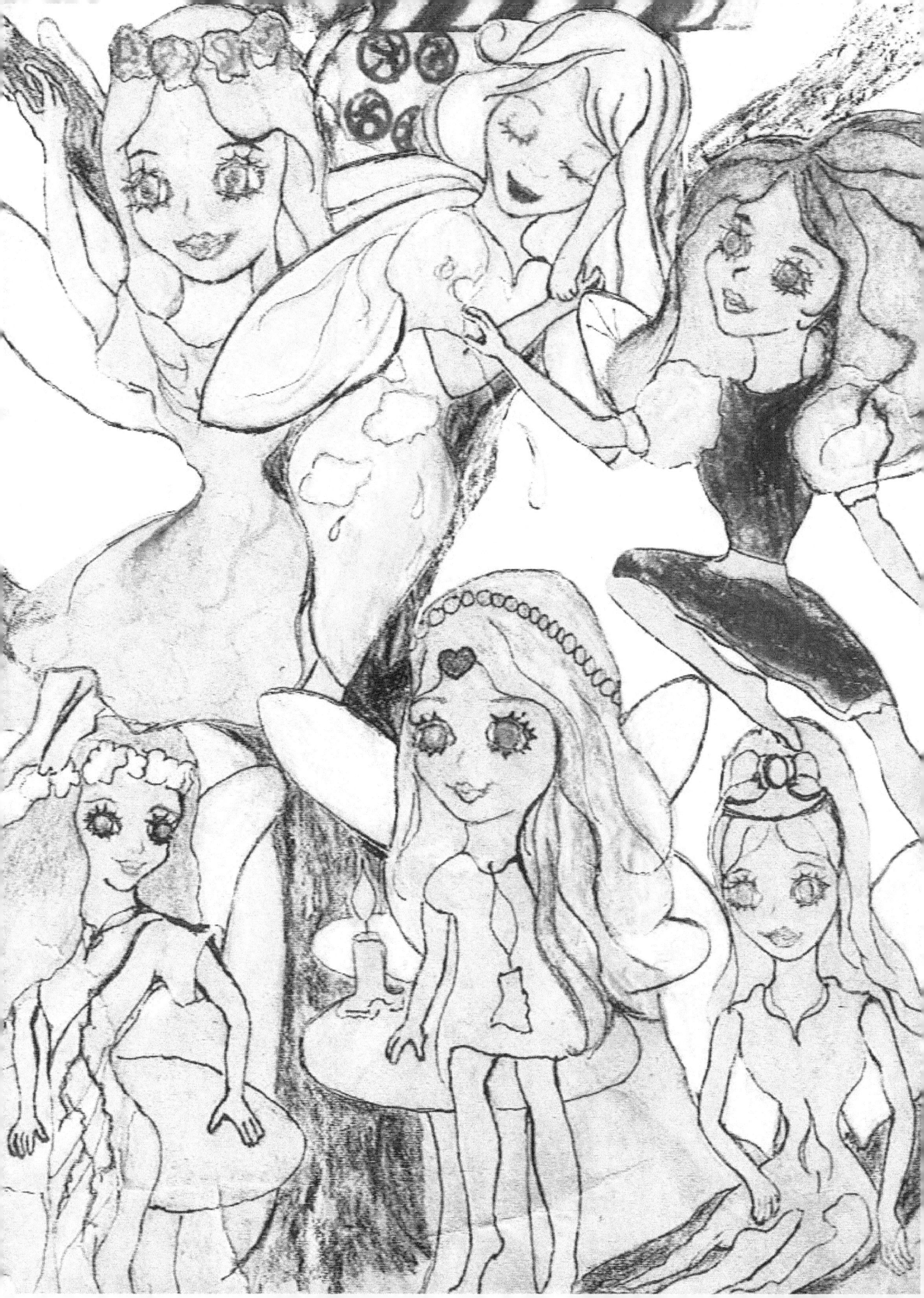

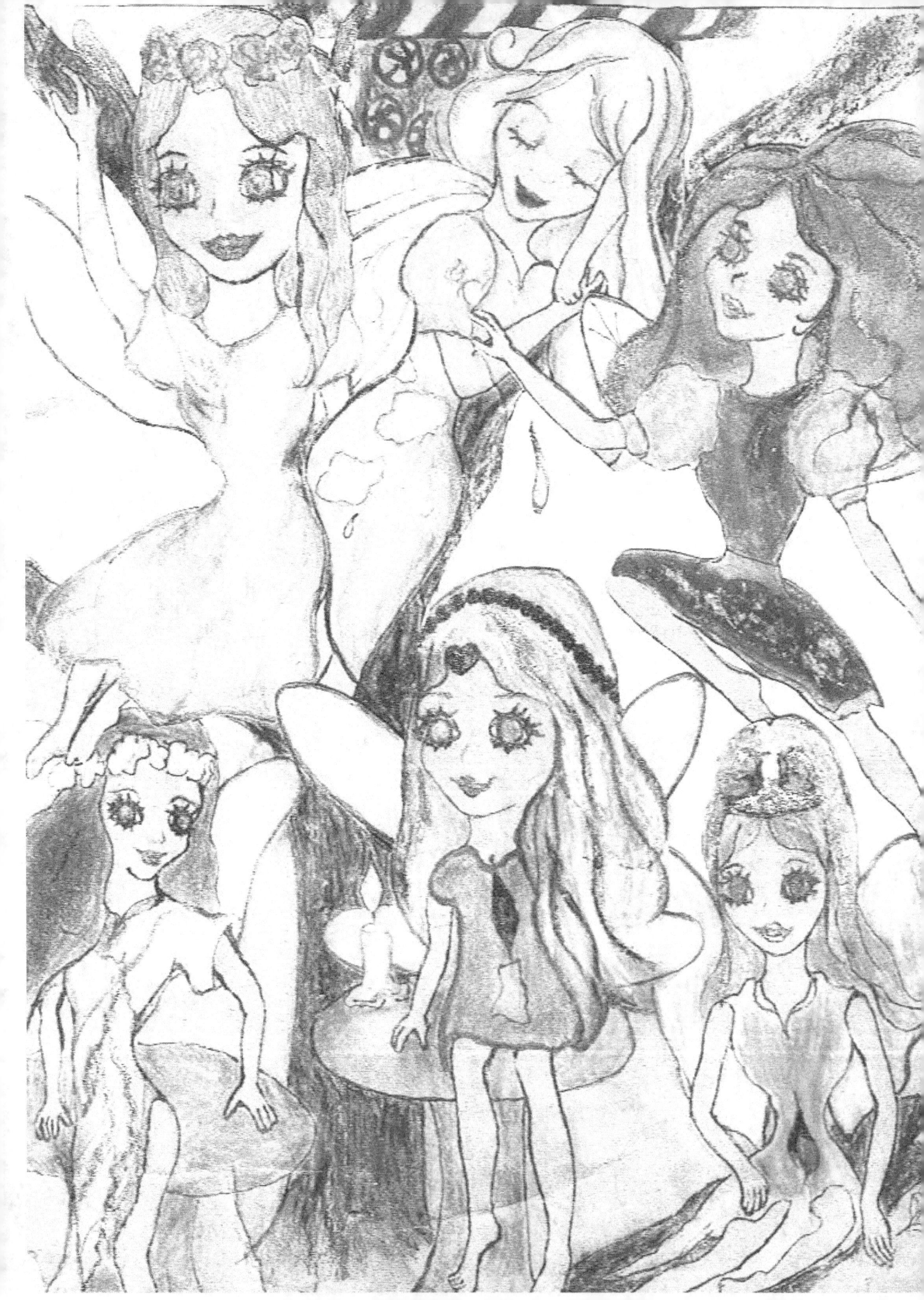

On the pages that follow one may discover
My fairy cards and portraits of the most amazing forest guardians
And their friends
Who are in family groups,
being assigned to earth, wind, fire, water, or electrical anomalies.
Each group features 10 gem-spirit guardians
Who may remind you of someone you know:

First, discover Botanical Garden Pixies and Elves.

Secondly, find the Wind Fairies.

Thirdly, the winged Solar Princesses delight you.

The Fourth group be Water Sprite,

And lastly, find extra-terrestrial Storm Elementals.

You may meet Treesa, with her gem pixies who assist botanicals;
Soo Delight, leader of the wind fairies, who lift seed to faraway ground;
And Zena, queen of astral Solar Princesses.
Lepidolita's water sprites are usually seen playing in moving water.
Chrysta introduces you to elementals, some from distant planets who
Transform this one.
You may learn about otherworldly phenomenon from them.

I hope you enjoy seeing their true colors.
Perhaps they will show you the hues they love to wear
so you may paint them.

I am enabling **Treesa** ancestral strength, empowering for the new journey

Pyritia

I am dynamic solar energy, the lightning force, flowing.

Femine energy facilitates my expression

That seed planted may flourish in truth

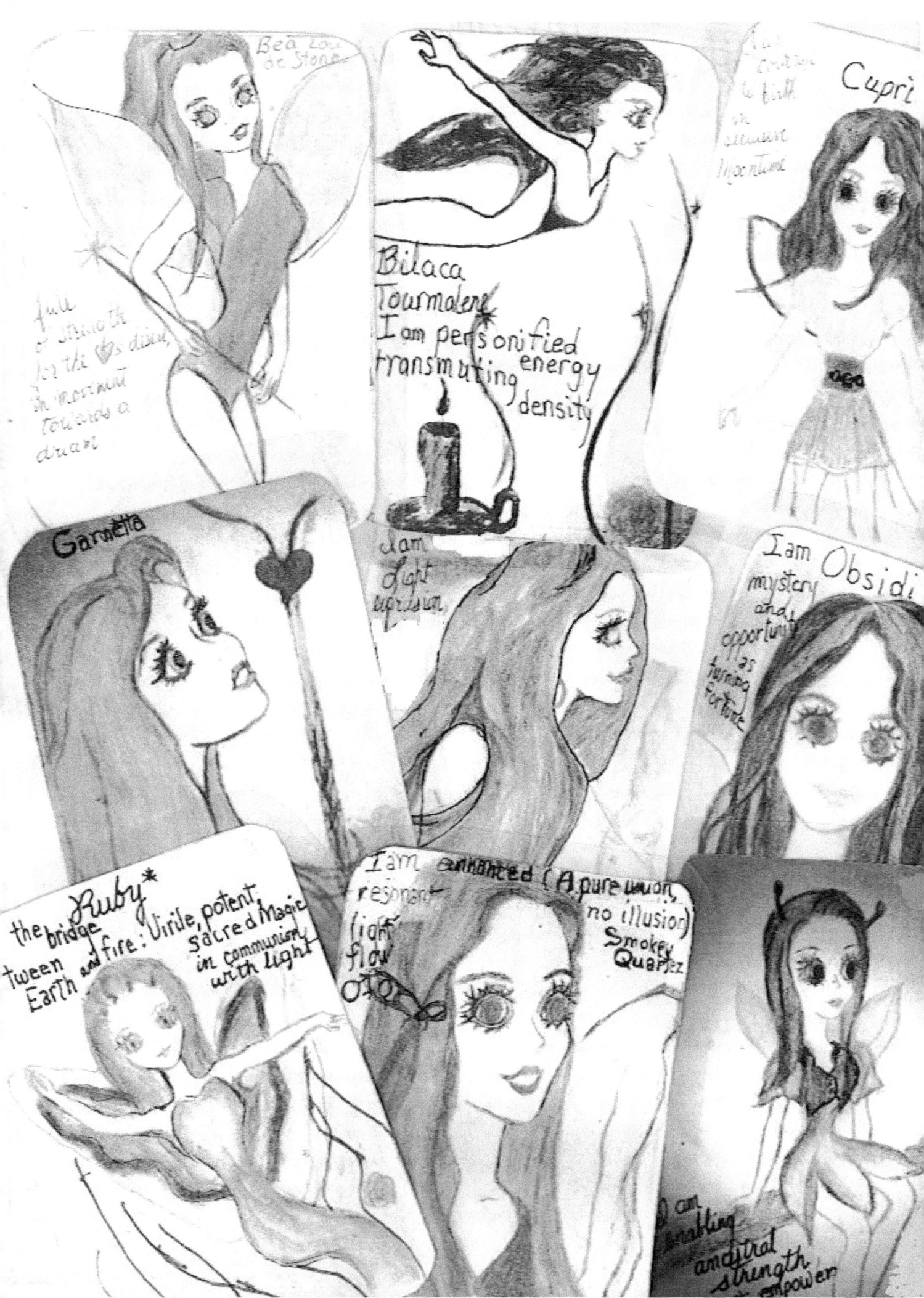

I am loving,
Bea Louise Stone
(Beatrice Louisa)

full of strength for the ♥'s desire, in movement towards a dream

Re-writing the script

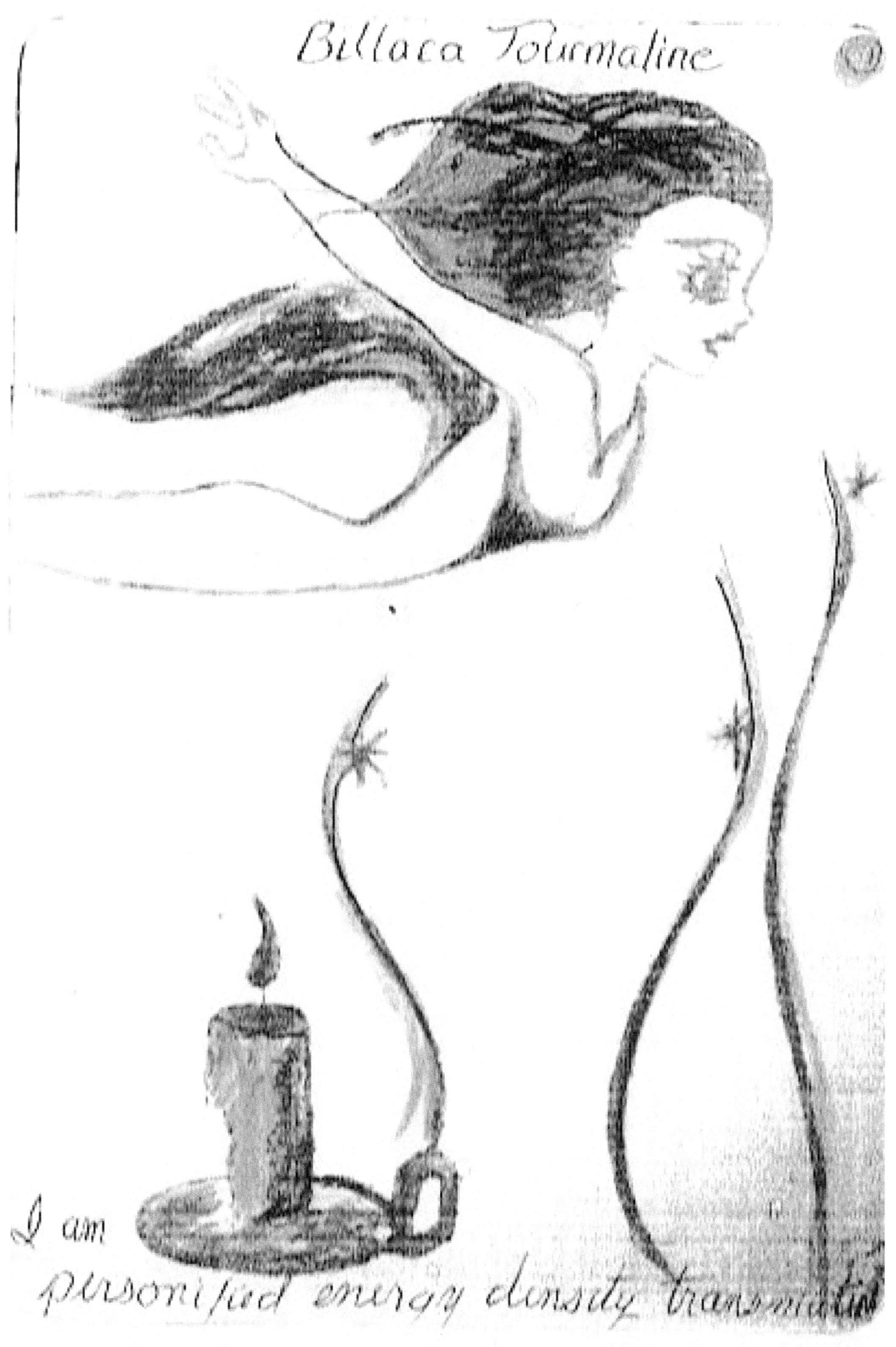

Cuprita

I am courage to birth in seclusive Moontime

I am regeneration of a low frequency

# Garnetta

fertility
in ecstatic fusion & expression

**Nematti**

I am the door of light expression resonant with Him.

manifest light

manifest light

I am ObsidiAnne
mystery & Opportunity     turning
                          fortune
                         to shield
                              one
                           from
                          games

I am the **Ruby** ✳︎ bridge between Earth and fire: virile, potent, sacred magic in communion with light.

I am resonant light-flow between a man and a woman. (enhanced) → A pure union, no illusion

Smokey Quartz

I am enabling ancestral strength, to empower for the new journey

Treesa

I am Desire, of the moment, **Soo Delite** intuitive adventure and self-creation, in beauty, explorin

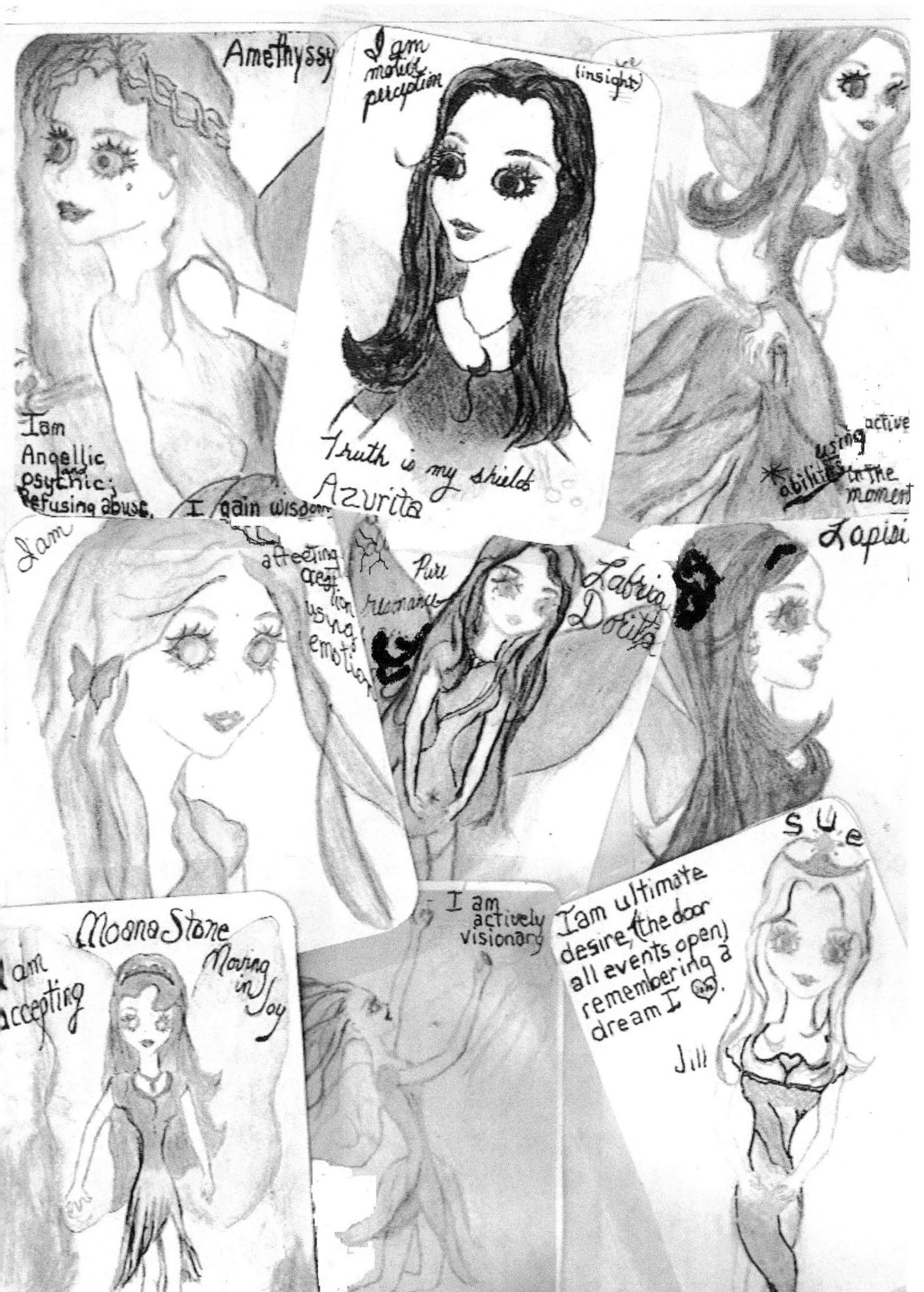

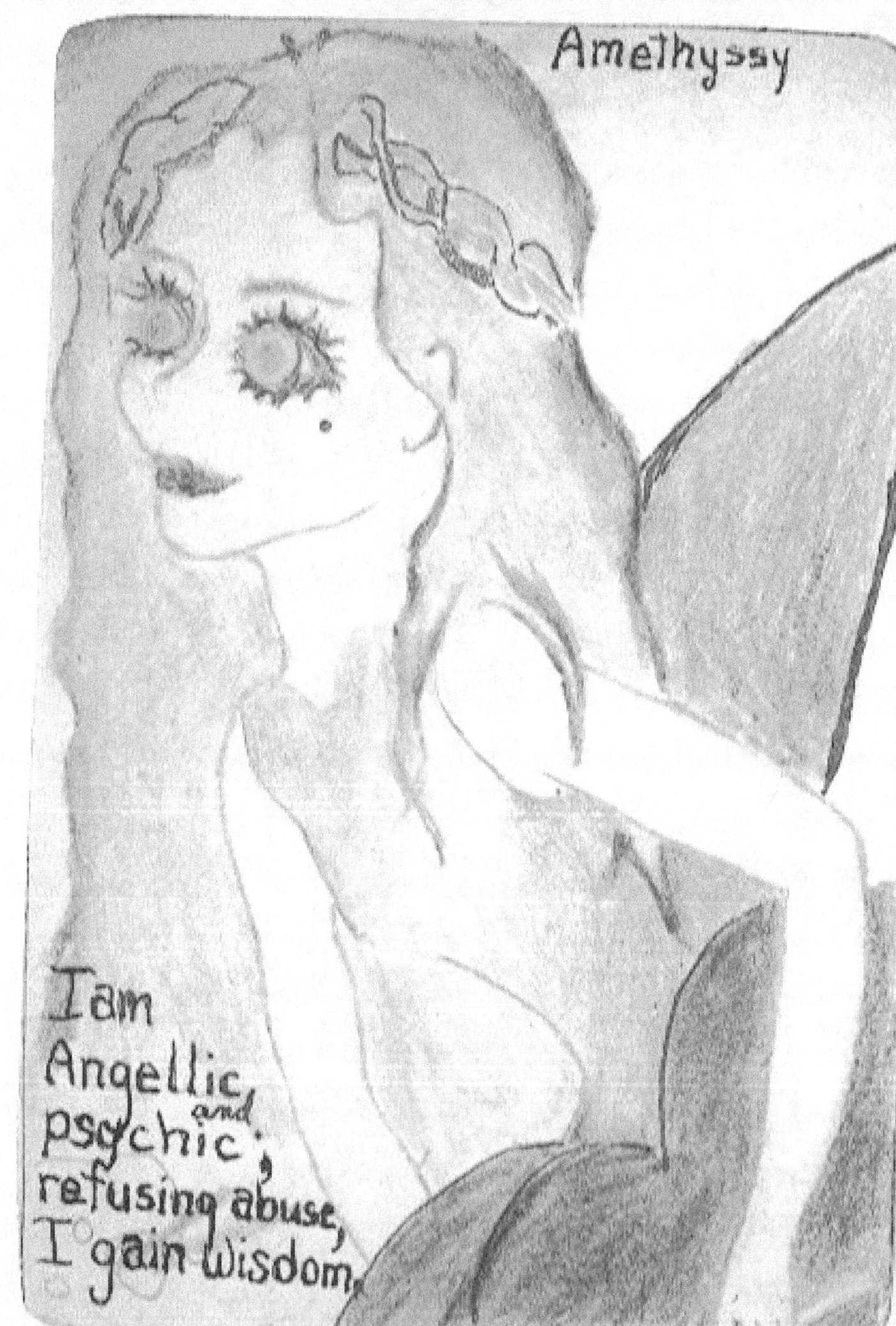

I am motive perception

Azurita (insight)

Truth is Amy shield*

Charo wyte

I am in surrender to pure knowlege and active ability and communication in the moment

I am Florita, applying light, affecting creation using emotion

I am *divination*: Pure Resonance with His Purpose

Labria Dorita

*I am psychic comprehension.*

**Lapisia Lazuli**

*of prayer and communion*

# Moana Stone

*I am accepting*

*Moving in joy*

I am actively visionary, resonating ♀/♂ femininity/masculinity; expressing Godiness to initiate change

Selena

# Soo Delite

I am Desire, of the moment, intuitive adventure and self-creation, in beauty exploring !!

(Journey)

I am ultimate desire, (the door all events open) remembering a dream I ♡love♡

Sue

Jill

Light

# Zena Kitte

I am divine, etheric, joyful Wishes, increasing creative life-force vitality for co-creation. Father clears my path.

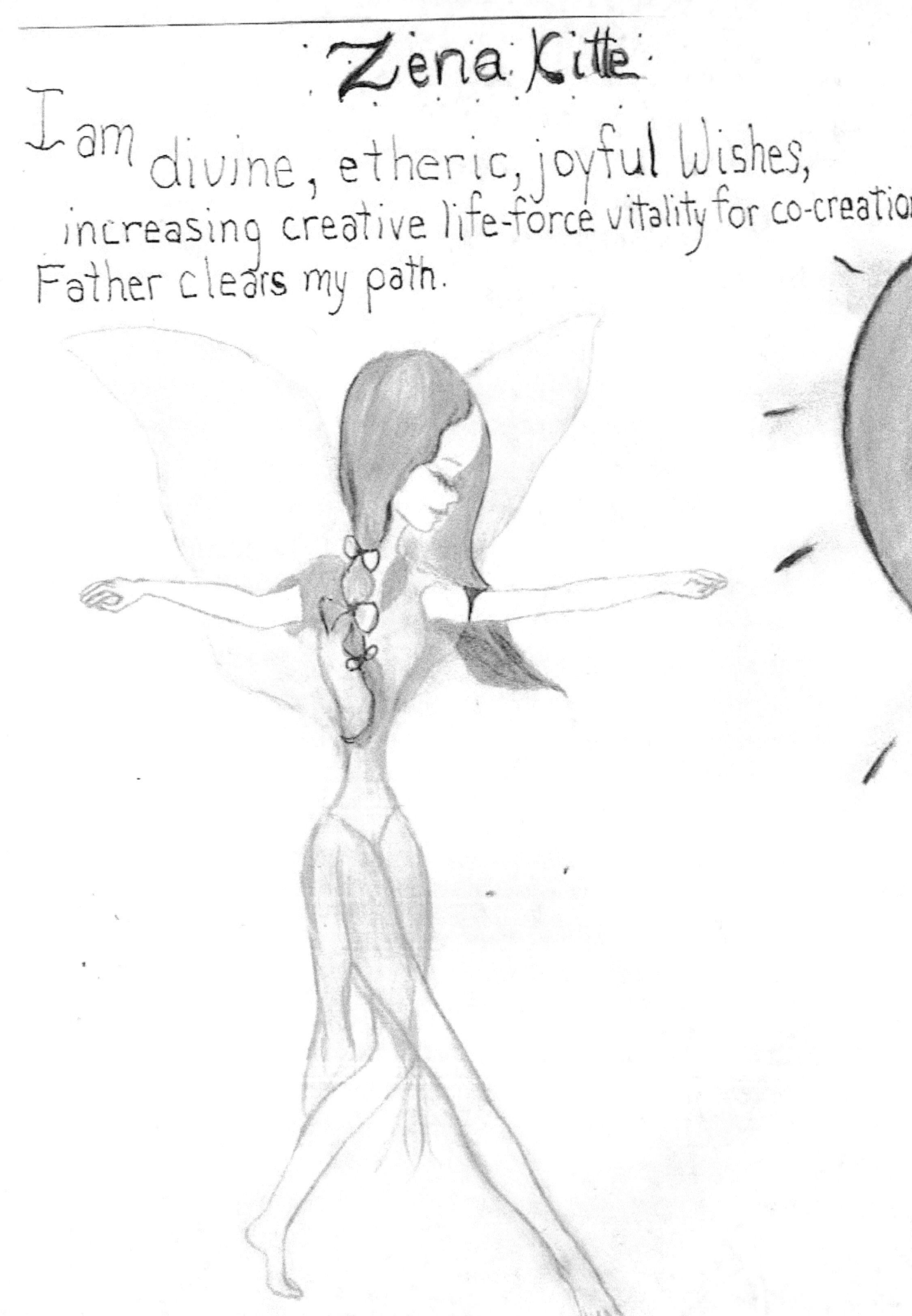

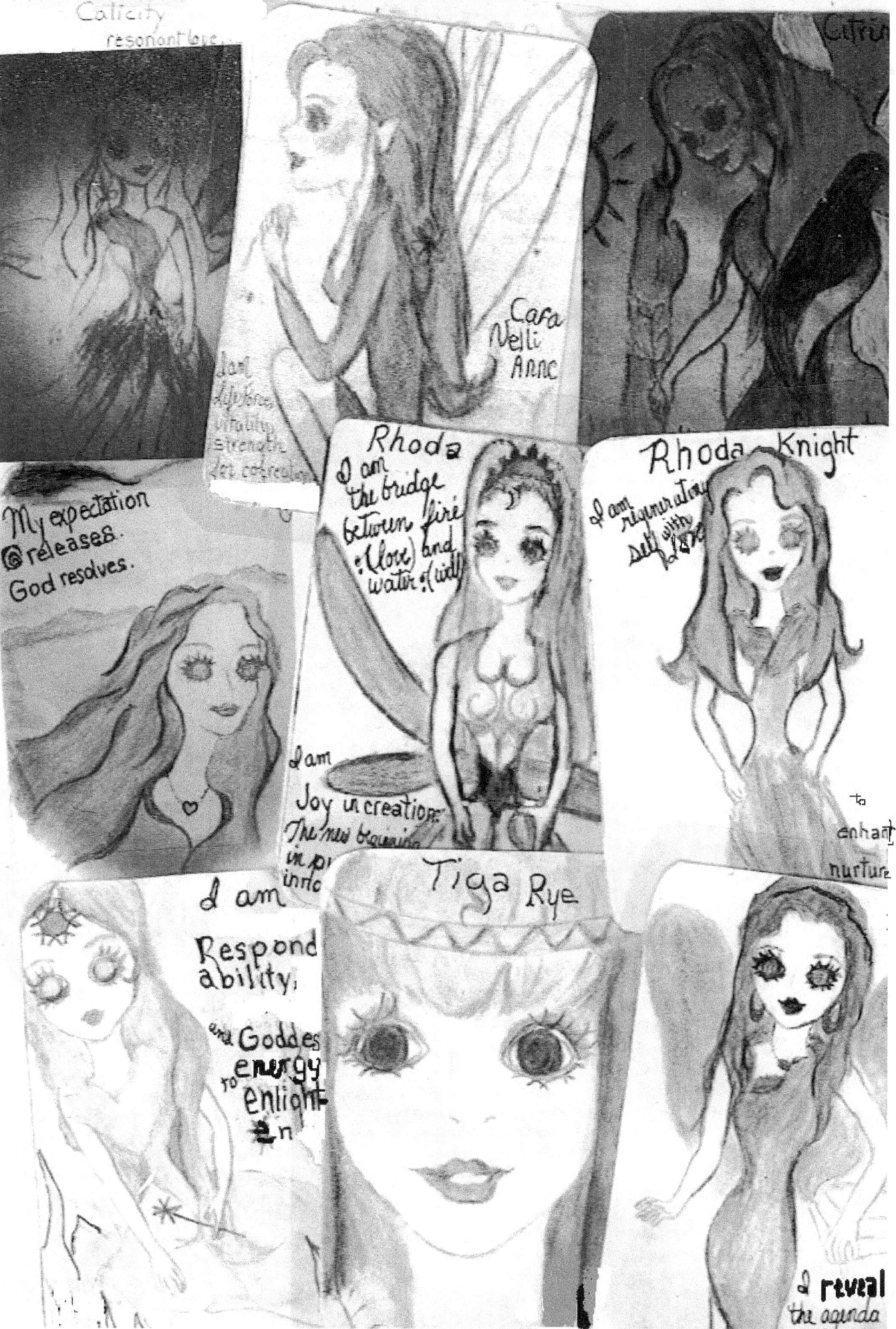

I call
**Beautiful emotion**
Calierty
in the moment of resonant love, allowing

Cara Nellianne

I am
Life Force,
vitality,
strength
for cocreation.
Moving into
dreams and
wishes

cleansing the
blood.
Father clears
my path.

Citrina

I am Mystery. I bring the power of beauty: Thought & desire aligned

Maula Kite
(will)
My expectation
ⓞreleases.
God resolves.

I am creating

# Rhoda Crowsight

I am the bridge between fire :(love) and water :(will)

I am Joy in creation: The new beginning in pure innocense.

(Child within)

# Rhoda Knight

I am regenerating self with Love

Beauty, worthiness, and power.

enhance my nurturing

Sun's Toni I am Sunpower, respond-ability, perception and Goddess-expression to enlighten in clarity.

TigaRye

I am perception enabling true ♡

# Topazze

*I am revealing the agenda thru discovery, intending joy* ♥

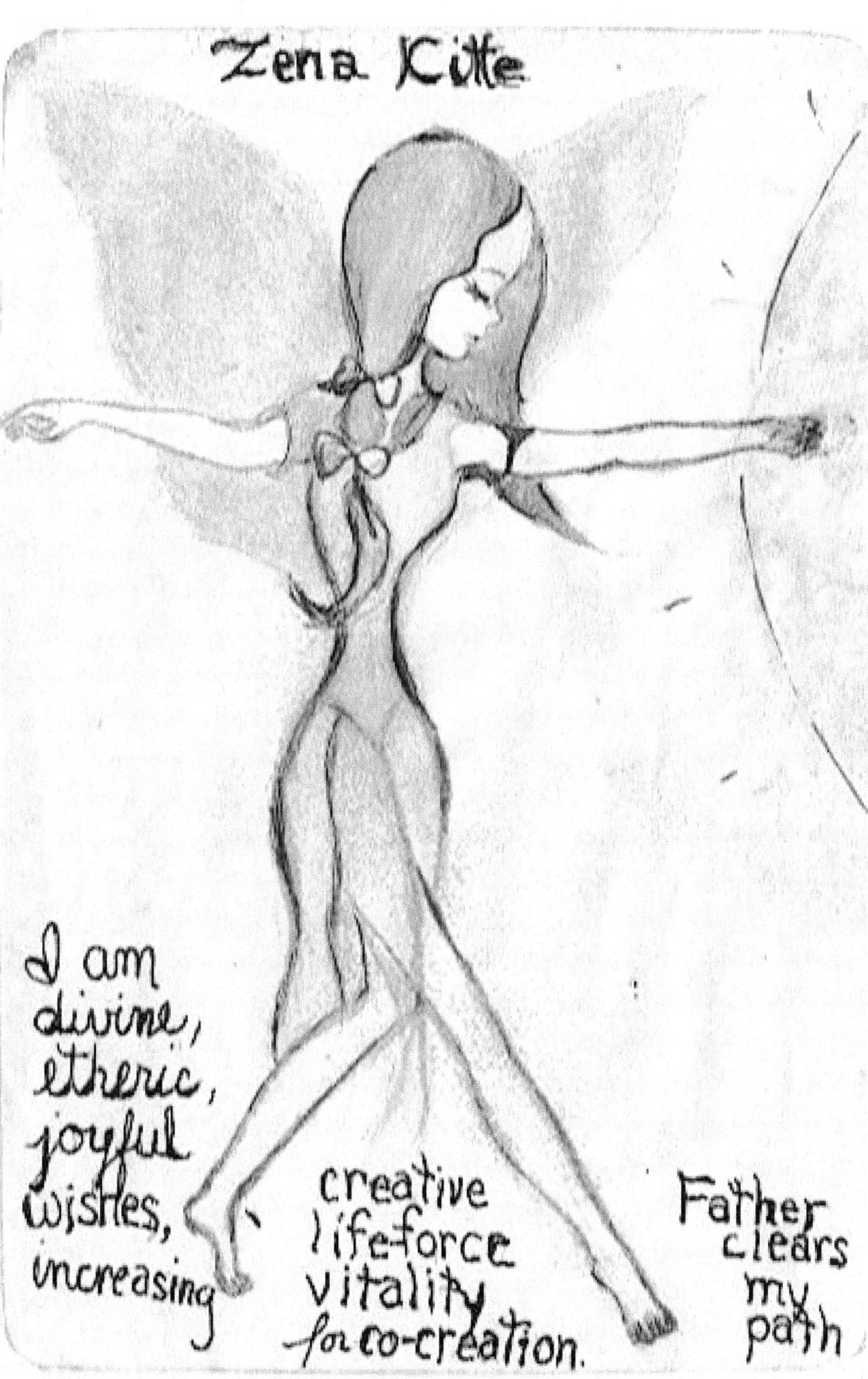

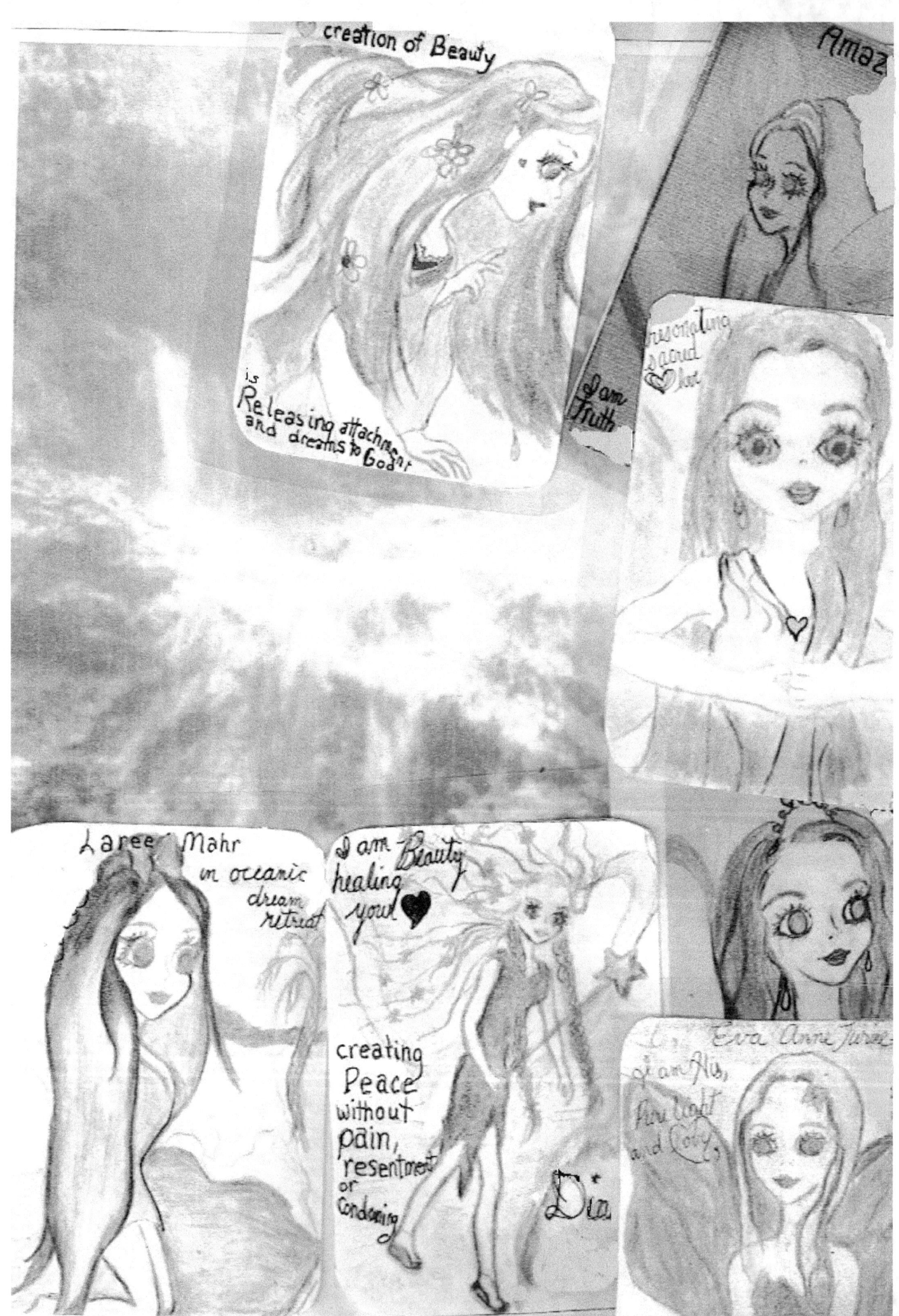

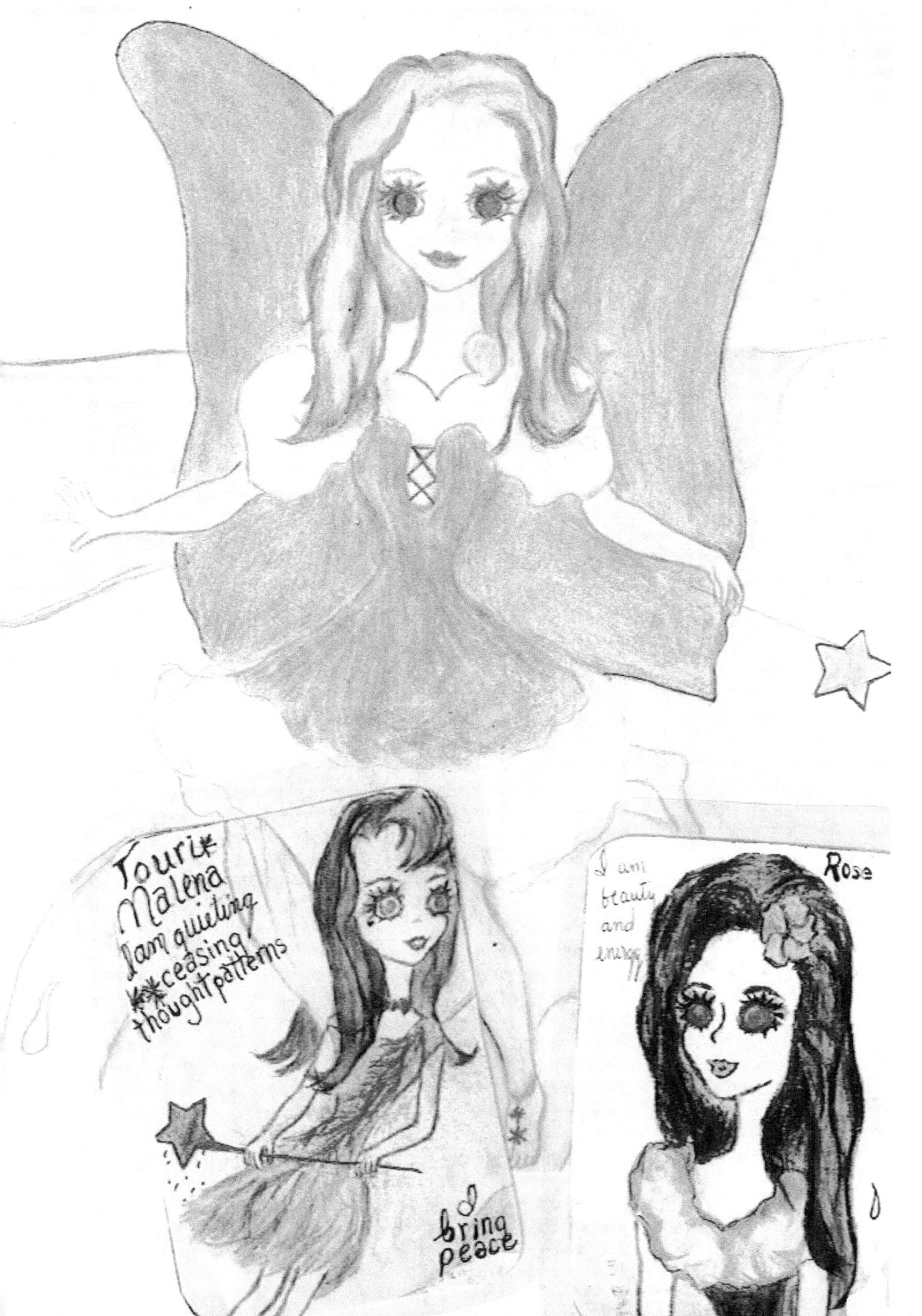

Aqua Marienne
I am enhanced perception, allowing creation of Beauty

Releasing attachment and dreams to God

I am truth - expressing to gain respect

Amazon I.T.
(Intellectual Terrestrial)
my Wisdom + Emotion & Open to God

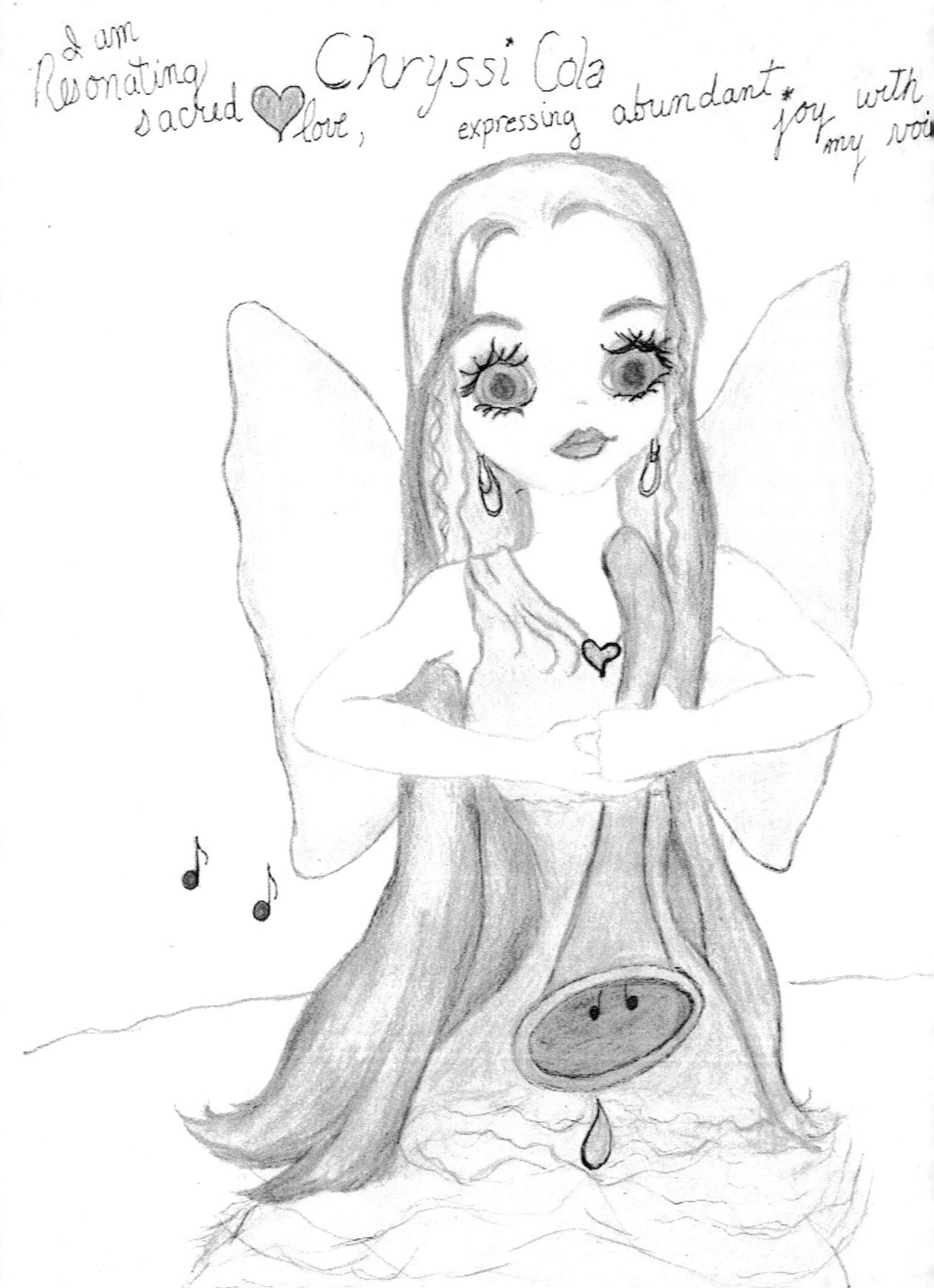

# Diah Ptassi

I am Beauty,
healing
your ♥,
creating
peace
without
pain,
resentment
or
condoning

I am His,   Eva Anne Turine*
Pure light and   health, riches, joy, (stormy).
(Love)

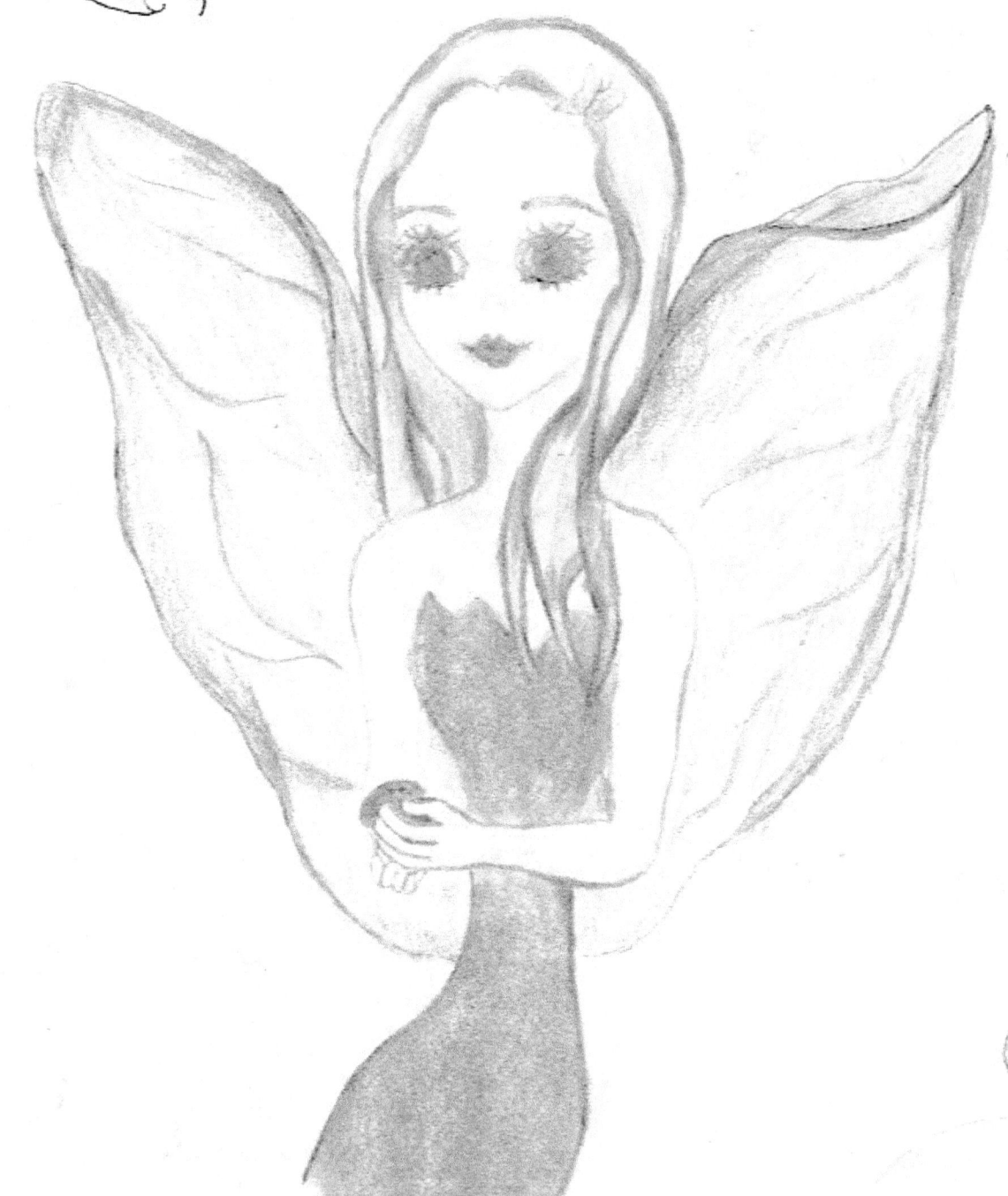

Choosing the New
          Me, melting, I release:
I am on a plateau, sensing, wishing, .... giving the old away.

I am  Kuna Zita
emotional expression, celebration of sacred love eternally creating and bonding with the created

I am Laree Mahr (nurtured) nurturing, soothing, cleansing care in oceanic dream retreat

Le Pidolita
I am lifting you to a bounteous shore, planning miracles in faith

releasing a situation

I am the beauty and energy

Rose Quartz (Love)

of Physical love

My truth does heal you

I am, quieting, ceasing thought patterns, bringing peace

Touri Malena

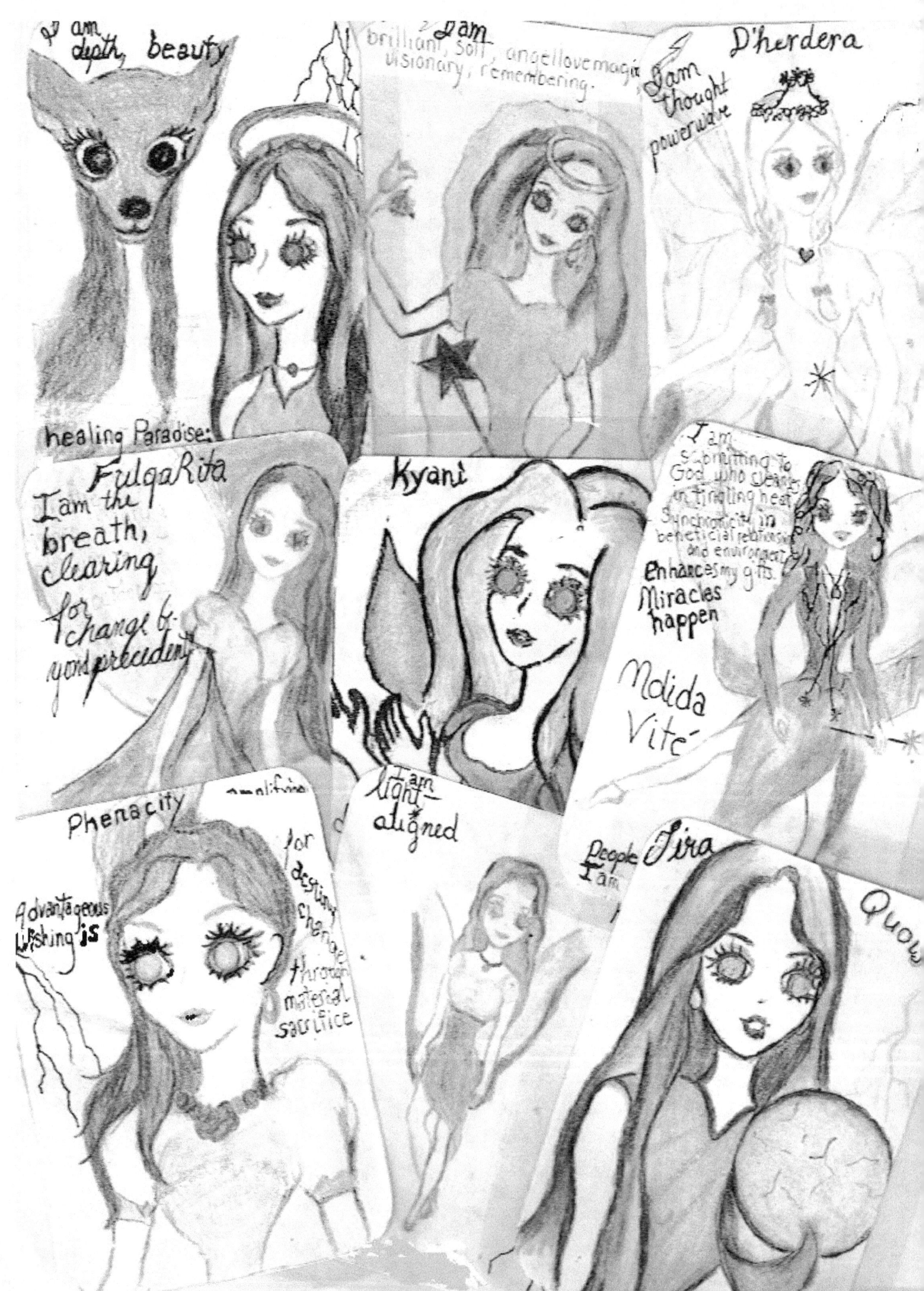

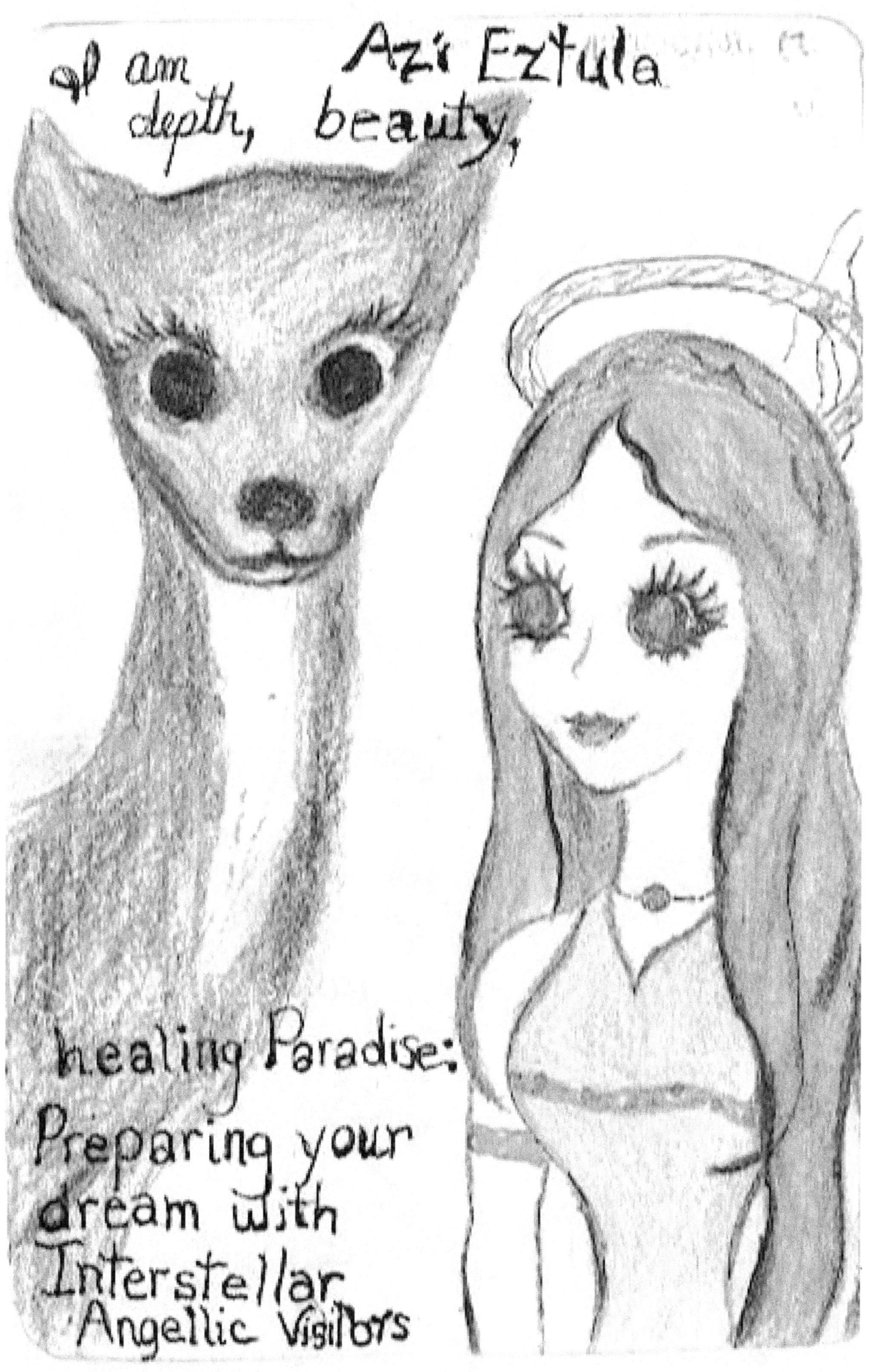

I am secret knowlege & mystery, promoting perception, amplifying ♡ desires upto God.

Chrysta Lynea Quartz

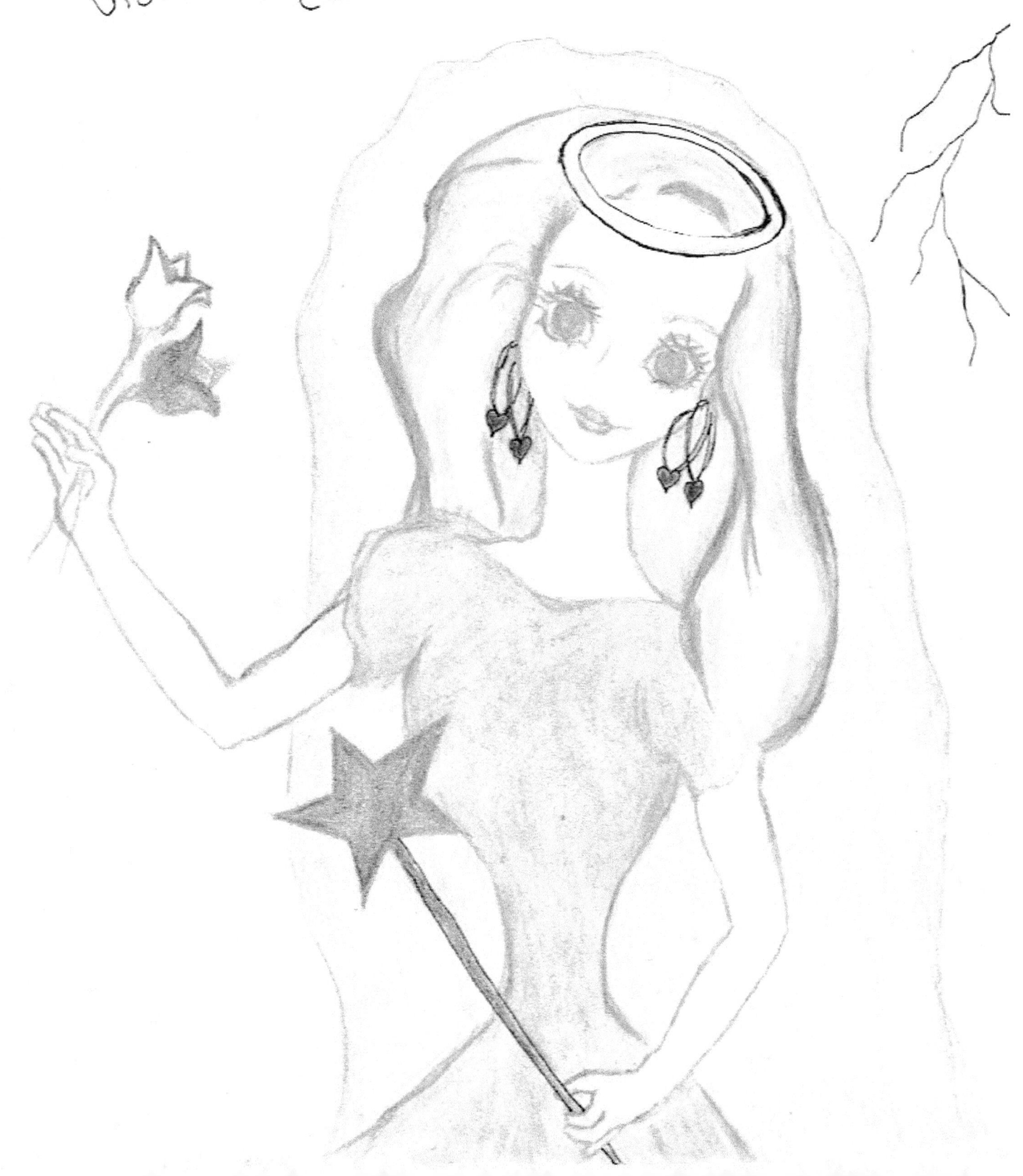

**D'herdera** for relationship evolution

I am thought powerwave

Enchanting Memory

Fulgarita

I am the breath, clearing for change *beyond* precident

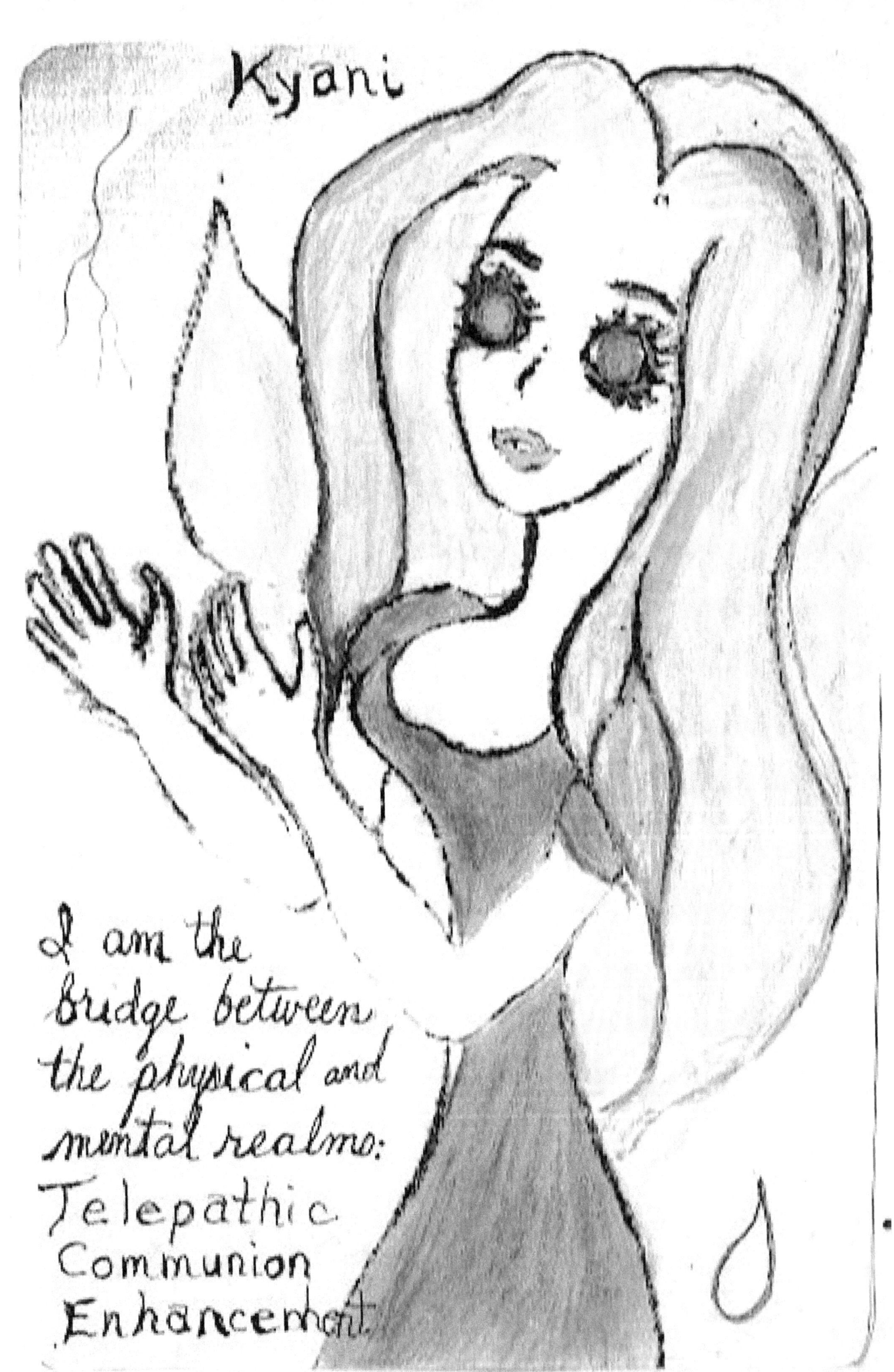

I am submitting Molida Kite to God who cleanses me in tingling heat, synchronicity, beneficial relationships, and enhances my environment, gifts

Miracles happen

People, lessons drop away I am drastic, immediate light transformation

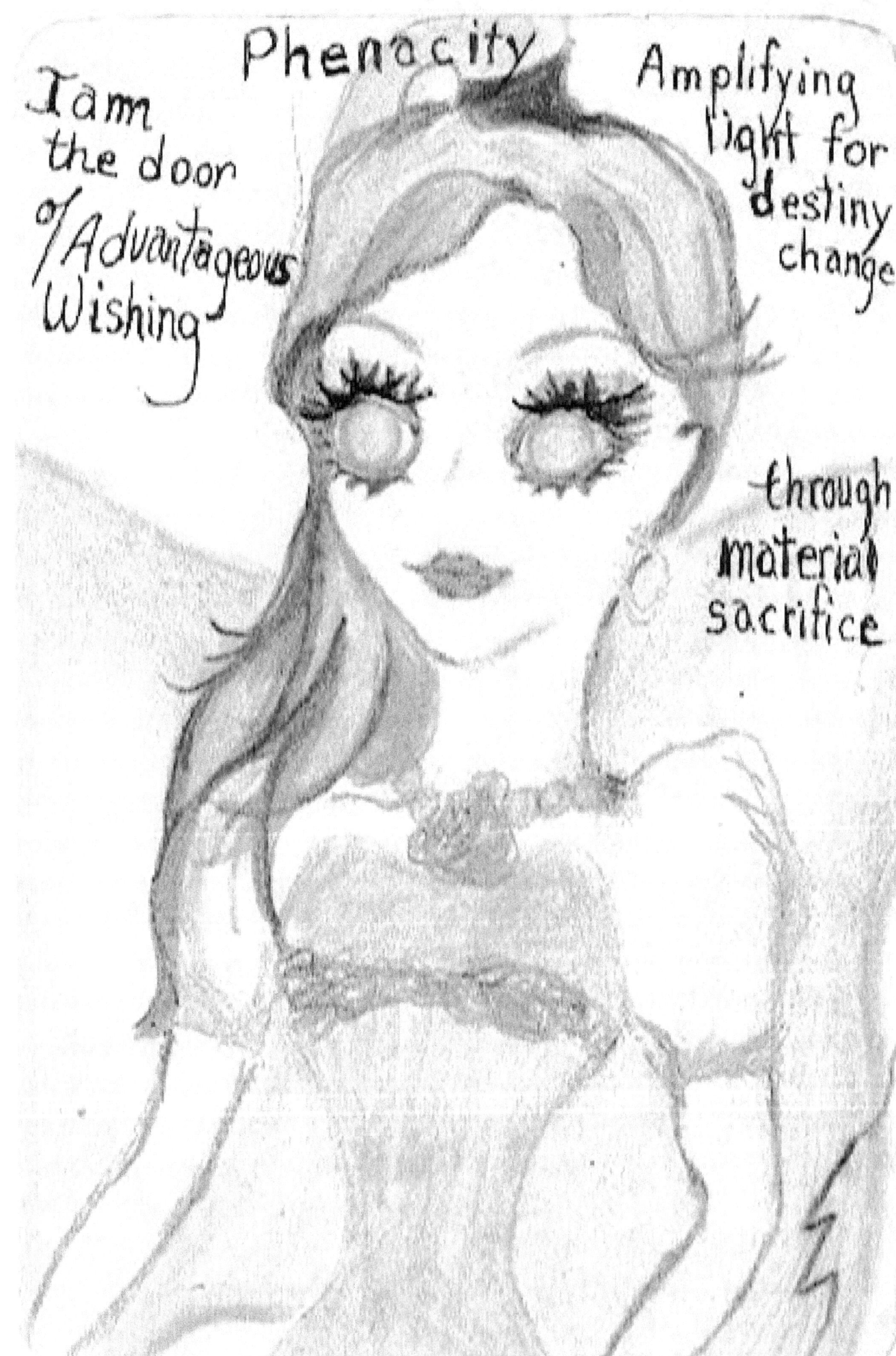

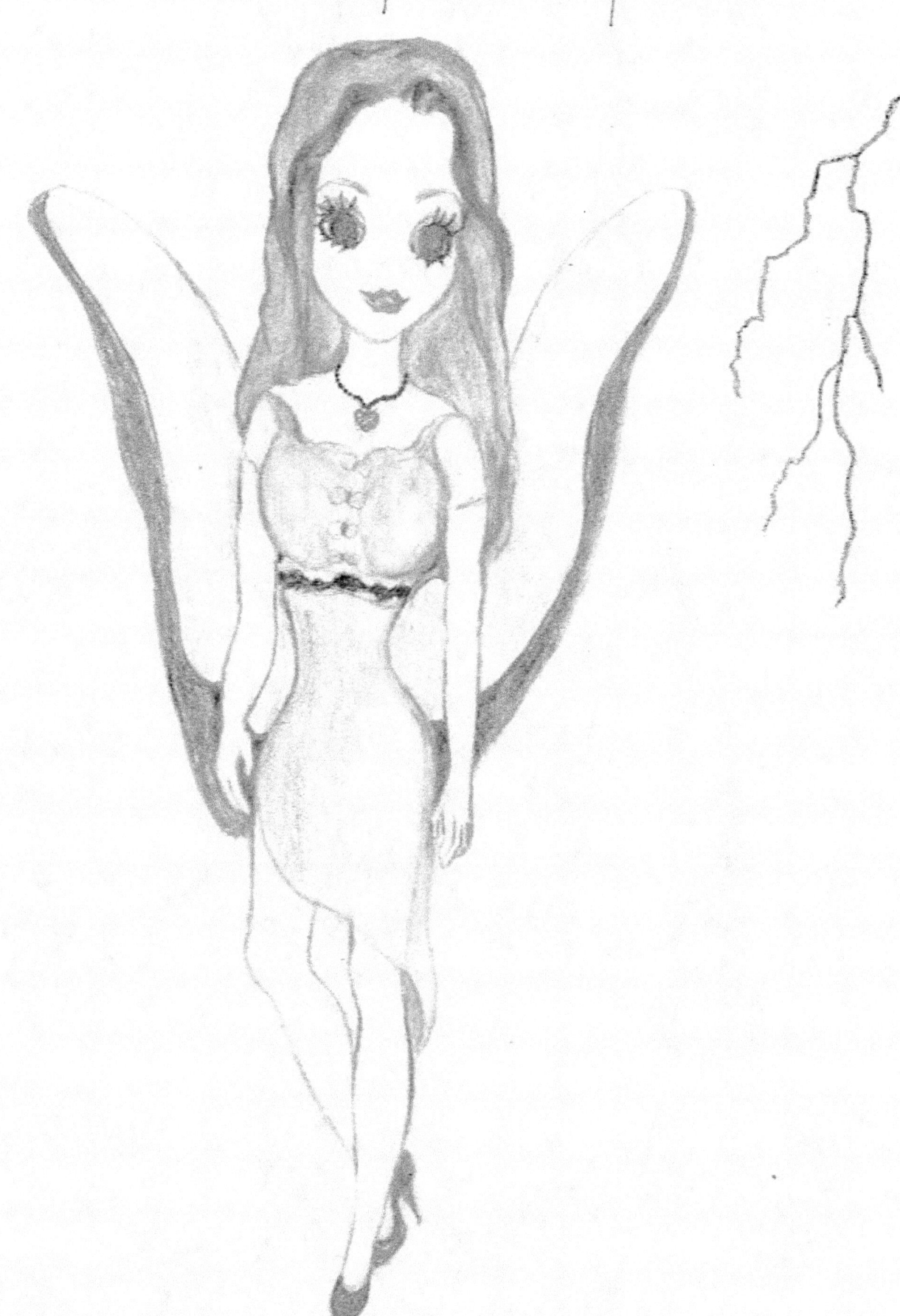

Tria
Turquoise

I am accepting all aspects of me